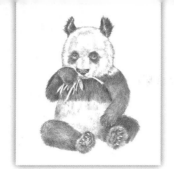

Wild Animals

Pencil drawing is a beautiful art form that also provides a wonderful starting point for beginning artists. Pencil is a forgiving medium, and the precision and control that pencil allows an artist make it an ideal tool for creating the intricate textures and fascinating features of a variety of wildlife species. In this book, experienced artist William F. Powell demonstrates how to use this versatile medium to render an exciting selection of wild animals—from playful chimpanzees to cuddly koalas—with clear and simple step-by-step instructions.

CONTENTS

GETTING STARTED

Drawing is probably one of the easiest art forms to master. And a wonderful aspect of drawing is that you can do it anywhere—you don't need many materials, and those you do require are easily transported and relatively inexpensive. But that doesn't mean you should buy the cheapest products you can find. Purchase the best quality you can afford initially, and then upgrade them whenever possible and as your budget allows. Remember that higher-quality materials will produce better results, and they will ensure that your animal drawings will last longer and not fade over time. Here are examples of the materials that will get you off to a good start.

▶ **SKETCH PADS** Drawing pads conveniently bound into book form are available in a wide variety of sizes, textures, and bindings. They are especially useful for making quick sketches and when drawing outdoors; they're perfect for sketching animals at the zoo. A good choice is one that has a smooth- to medium-grain paper texture, which is referred to as the "tooth." (For more on sketching, see page 7.)

▲ **THE WORK STATION** Set up a work area that has good lighting and space enough for you to lay out all your tools. The ideal would be to have an entire room or separate studio with a lights, an easel, and a drawing table, like the one shown above. But all you really need is a place by a window for natural lighting. If you draw at night, use both a soft white light and a cool white fluorescent light so you have both warm (yellowish) and cool (bluish) light.

▶ **DRAWING PAPERS** For finished works of art, most artists use single sheets of higher quality drawing paper. You can find papers in a range of different surface textures: smooth grain (plate and hot pressed), medium grain (cold pressed), and rough to very rough. The cold-pressed surface is probably the most versatile. It has a medium texture but it's not completely smooth, which makes it a good surface for a variety of different animal textures.

◀ **ERASERS** A kneaded eraser is an essential tool. It can be formed into small shapes to remove pencil from very tiny areas. Vinyl erasers are best for larger areas, and they remove pencil marks completely. As long as you don't scrub too vigorously, neither type will damage the surface of your paper.

▶ **CHARCOAL PAPERS** Charcoal paper and tablets are also available in a variety of textures. Some of the surface finishes are quite rough, so you can use them to enhance the texture in your animal drawings. These papers also come in a variety of colors, which can add depth and visual interest to your work.

▶ **BLENDING STUMPS** *Tortillons* are paper "stumps" used to blend and soften pencil strokes. They're handy for small areas where your finger or a cloth is too large. You can also use the sides to quickly blend large areas. When the stumps become dirty, simply rub them on a cloth to remove the excess graphite.

▲ **UTILITY KNIVES** These knives (also called "craft" knives) will cleanly cut drawing papers and mat board. You can also use them for sharpening pencils. (See the box on page 3.) The blades come in a variety of shapes and sizes, but they are very sharp; so great care must be taken when using craft knives.

Collecting the Tools

When shopping for pencils, notice that they are labeled with numbers and letters; these indicate the degrees of softness of the lead (which is actually graphite). Pencils with B leads are softer than ones with H leads, and so they make darker strokes. An HB is in between, which makes it very versatile and a good beginner's tool. The chart at right shows a variety of drawing tools and the kind of strokes you can achieve with each one. To complete the projects in this book, you'll need only HB and 2B pencils; but as you expand your pencil supply, practice using a variety of hardnesses. Also try shaping different points to create a range of effects by varying the pressure you put on each pencil.

Adding Extras

Unless you already have a drawing table, you might want to buy a drawing board. You don't have to spend a lot of money on a board; just get one large enough to hold individual sheets of drawing paper. Consider getting one with a cut-out handle, especially if you want to draw outdoors, so you can easily carry it with you.

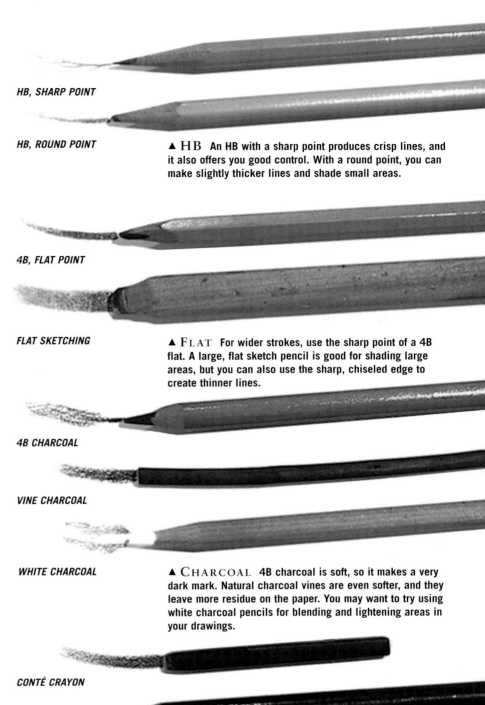

HB, SHARP POINT

HB, ROUND POINT

▲ HB An HB with a sharp point produces crisp lines, and it also offers you good control. With a round point, you can make slightly thicker lines and shade small areas.

4B, FLAT POINT

FLAT SKETCHING

▲ FLAT For wider strokes, use the sharp point of a 4B flat. A large, flat sketch pencil is good for shading large areas, but you can also use the sharp, chiseled edge to create thinner lines.

4B CHARCOAL

VINE CHARCOAL

WHITE CHARCOAL

▲ CHARCOAL 4B charcoal is soft, so it makes a very dark mark. Natural charcoal vines are even softer, and they leave more residue on the paper. You may want to try using white charcoal pencils for blending and lightening areas in your drawings.

CONTÉ CRAYON

CONTÉ PENCIL

▲ CONTÉ CRAYON OR PENCIL Conté crayon is made from very fine Kaolin clay. Originally it came only in black, white, red, and sanguine sticks, but now it's also available in a wide range of colors. It's also water soluble, so you can blend it with a wet brush or cloth.

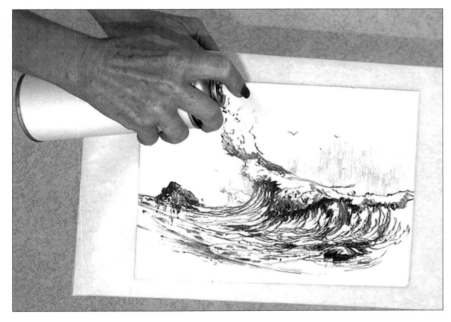

SPRAY FIX A fixative "sets" a drawing and protects it from smearing. Some artists don't use fixative on pencil drawings because it tends to deepen the light shadings and eliminate some delicate values, but it is very good for charcoal drawings. Fixative is available both in spray cans or in bottles; the latter requires a mouth atomizer. Spray cans are more convenient, and they give a finer spray and more even coverage.

SHARPENING YOUR DRAWING TOOLS

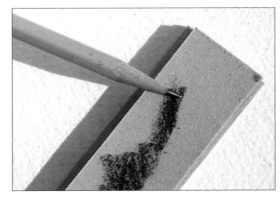

A CRAFT KNIFE can create a wider variety of pencil points (chiseled, blunt, or flat) than an ordinary pencil sharpener can. Hold the knife at a slight angle to the pencil shaft, and always cut away from you, taking off only a little wood and graphite at a time.

A SANDPAPER BLOCK will quickly hone the lead into any shape you wish, also sanding down some of the wood. The finer the grit of the paper, the more control you have over the final point. Roll the pencil in your fingers when sharpening to keep the shape even.

ROUGH PAPER is a great way to smooth the pencil point after tapering it with sandpaper. It can also be used to create a very fine point for drawing small details. As with sandpaper, gently roll the pencil while honing it to make sure you sharpen the lead evenly.

3

PRACTICING BASIC TECHNIQUES

Animals offer a wide range

of textures to reproduce on paper. From the thick, wrinkled skin of an elephant to the soft, furry coat of a panda, you can manipulate graphite to imitate almost any texture. But before you begin the projects in this book, take time to get acquainted with your tools and become comfortable making a variety of strokes. Try holding the pencil with the different grips shown below, and experiment with creating form using variations of light and dark. Then practice rendering the examples of textures demonstrated on the opposite page to help you to understand what effects you can achieve with various pencils and techniques. You can also refer back to these pages for basic instruction on fur patterns and hair types whenever needed as you create your own original animal drawings.

Shading to Create Form

To transform simple *shapes,* or outlines, into convincing three-dimensional *forms,* you will need to apply shading. Shading involves using different *values*—the lightness or darkness of the strokes. Applying less pressure gives you lighter values, and applying more pressure results in darker values, as shown in the example below. Learning to shade will help you create realistic animals that seem able to walk off the page!

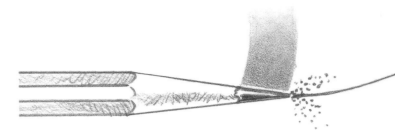

SHARP POINT Use either a handheld or electric sharpener for a simple, sharp tip. You will get a very fine point that you can use to create extremely thin lines and small details. You can also use the side of this tip to produce thick strokes of graphite—perfect for quickly shading large areas of smooth fur or backgrounds.

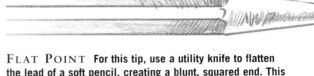

FLAT POINT For this tip, use a utility knife to flatten the lead of a soft pencil, creating a blunt, squared end. This shape can produce a variety of different strokes simply by changing the angle of the pencil to the paper; use the edge for the thin lines of your animal, and use the flat tip for wide lines.

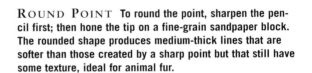

ROUND POINT To round the point, sharpen the pencil first; then hone the tip on a fine-grain sandpaper block. The rounded shape produces medium-thick lines that are softer than those created by a sharp point but that still have some texture, ideal for animal fur.

BLENDING To blend your individual strokes into a single mass, use the side of the rounded tip of a tortillon. The blended strokes can represent smooth skin or very soft fur.

SHAPE

FORM

GRIPPING THE PENCIL

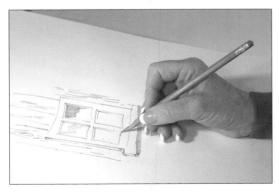

HANDWRITING The handwriting position provides the most control, and the accurate, precise lines that result are perfect for fine fur details and accents. When you use this position, place a clean sheet of paper under your drawing hand to prevent your palm from smudging your drawing. And sharpen your pencils often to keep your strokes delicate.

BASIC UNDERHAND The basic underhand position allows your arm and wrist to move freely, making it ideal for large, loose sketches. Practice this position when sketching animals from life. You can also use this position to create flat strokes, which are essential for blocking in large areas of shading for fur, hides, and even background elements.

UNDERHAND VARIATION For the underhand, or mid-hand position, hold the pencil lightly and vary the pressure to create a range of expressive lines. This position produces more precise, detailed strokes than the basic underhand position does, but the result is still rather loose. The soft lines are ideal for quick sketches on site and for smaller areas of shading or texture.

CREATING ANIMAL TEXTURES

Solid Fur

STEP 1 Use the side of an HB lead to cover the surface with even, vertical strokes. Apply layer on layer to build depth.

STEP 2 Next use the corner of a vinyl eraser to pull out thick, light hairs that follow the direction of hair growth. Lift up the eraser at the end to create tapered points.

Striped Fur

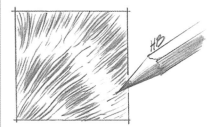

STEP 1 For striped or spotted fur, begin to suggest the dark hairs with the side and point of an HB pencil, placing the strokes close together.

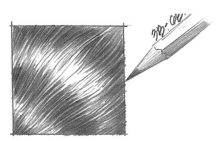

STEP 2 Now define the overall texture and add details and the darkest values with a range of soft pencils, from 3B to 6B. Use a paper stump to soften the darkest areas.

Thick Fur

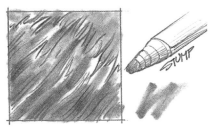

STEP 1 Create thin, dark lines with an HB pencil. Then rub a tortillon over some of the strokes to soften and blend them, leaving a few untouched.

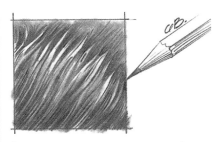

STEP 2 Then use a sharp 6B pencil to refine the texture, always stroking in the direction of fur growth. Pick out some white highlights with an eraser.

Whiskers

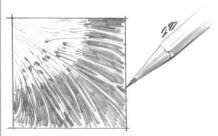

STEP 1 Indicate the light whiskers by shading the underlying fur, using the side and the point of a sharp 2B pencil. Darken the areas where the whiskers originate.

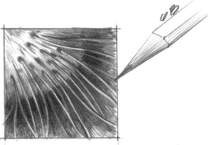

STEP 2 Use a 6B pencil to refine the whiskers and shade the darkest areas. Defining the whiskers by drawing around them is called "drawing the negative shapes."

Smooth Hair

For relatively smooth coats, draw short parallel strokes with the pencil point. To keep the hair from looking flat, suggest underlying forms with dark and light areas.

Rough Hair

To depict rough coats, vary the direction of your pencil strokes slightly, curving some and overlapping others a bit haphazardly. Keep your strokes somewhat loose and free.

Long Hair

To create long hair—whether it's the whole coat or just a mane or tail—use longer, sweeping strokes with some curvature. Use more pressure on the pencil for dark values.

Silky Hair

To render a silky coat, apply light pressure on the pencil and leave the highlighted areas completely free of graphite. Use the same strokes used for long hair.

Parted Hair

Some animals have decided parts in their long hair. Leave an irregular line unshaded for the part, and make all the hairs originate from the part and sweep up and out.

Curly Hair

Curly coats can be reproduced with long, overlapping circular strokes of varying values. To help make them look realistic, draw curls of differing shapes and sizes.

Rough Hide

For hairless hides and rough patterns, use the side of the pencil and make very short, blunt strokes in varying directions. Alter the values to show either form or color patterns.

Bare Nose

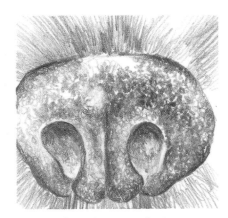

Whether moist or dry, most animal noses have a similar texture. Make small, circular strokes or very short straight strokes with the side of the pencil, leaving the highlight white.

DRAWING FROM PHOTOGRAPHS

Photographs are wonderful references

for drawings of animals. When you take the photos yourself, try to catch a motion or pose that is characteristic of the animal, such as the position of a cheetah just before it pounces or the stretch of a spider monkey in mid-swing. Always be prepared to take a snapshot at any time and take several different shots of the same subject; it is challenging to capture the animal's personality on disk or film, but it is well worth the wait!

When you are ready to begin drawing, look over all your photographs and choose the one you like best. But don't feel restricted to using only one reference source. You may decide you like the facial expression in one photo but the body pose in another; you may even have other references for background elements you'd like to include. Use them all! Combine your references any way you choose, altering the scene to suit yourself. That is referred to as "taking artistic license," and it's one of the most important "tools" artists have at their disposal.

▶ **COPYING A PORTRAIT**
This drawing was based on the photo reference shown above. It captured the proud, strong expression and physical characteristics so typical of mature male gorillas. Because the photo was so clear, the drawing follows it faithfully.

▶ **COMBINING REFERENCES** These two photos were used for the drawing at right. The photo of a polar bear walking clearly shows the animal's shape and proportions. But the other photo reference features the face more clearly.

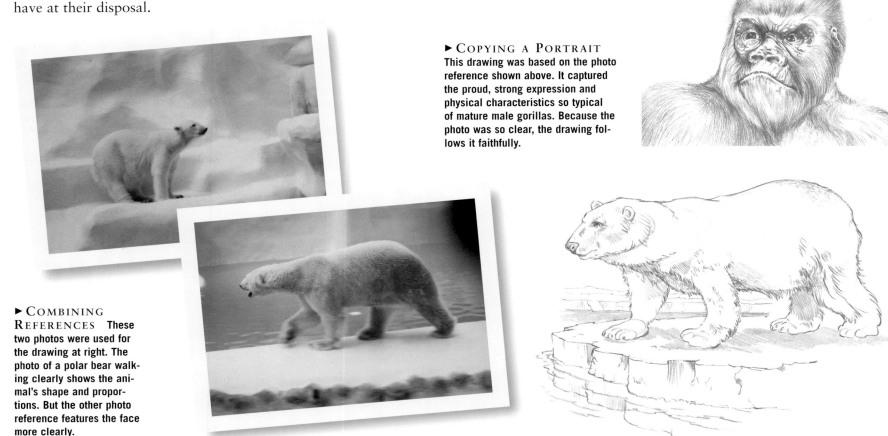

CREATING AN ARTIST'S MORGUE

The more skilled you become at drawing and the more different animals appeal to you as subjects, the more references you'll want to have on hand. Many artists keep some type of file for storing images, also called an "artist's morgue." This system of collecting film prints, slides, and digital images can supplement the information you note in your sketchbook (see page 7), such as the color, texture, or proportions of a subject. You may also want to include magazine clippings, postcards, or other visual materials in your file, but be sure to use these items as loose references for general information only; replicating another's work without permission is a copyright infringement.

Artists today are fortunate to have many means of obtaining and cataloging pictures. You can store thousands of photos on CDs, and each picture can be pulled up on screen in a matter of seconds. If you choose to create physical folders, you might want to file your images alphabetically by subject so they are easily accessible when the need for a reference arises. And you can use all forms of storage for your artist's morgue—you can even print still-frame shots from your own scenic videos.

DRAWING FROM LIFE

Sketching animals from life gives you
a fresh approach to drawing that is spontaneous and original—every pose and composition you discover is unique! Creating a finished drawing on site has its disadvantages, however; you may not be able to stay on location for the duration of the drawing, and the light shifts as time passes, changing the shadows and highlights. And, of course, most animals are bound to change positions or even walk away as you work, making it difficult for you to capture a good likeness. Instead of trying to produce a final, detailed pencil drawing in the field, use a sketchbook to gather all the information you'll need for a completed piece later. Work quickly and loosely, concentrating on replicating the animal's general shapes, main features, gestures, and expressions. Practice using your whole arm to draw, not just your wrist and hand. Vary the position of your pencil as you stroke, and involve your shoulder in each movement you make. Then jot down notes to complete the information you'll want to retrieve later. When it comes time for the final drawings, you'll be surprised at how often you'll refer to the notes you've recorded in your sketchbook!

DRAWING AT THE ZOO The zoo is an ideal place for sketching a wide range of interesting animals. Before you begin to draw, take some time to observe their general proportions, as well as the way the animals move and how they interact with one another. The more you know about your subject, the more convincing your drawings will be.

▶ **KEEPING A SKETCHBOOK** When you sketch from life to prepare for a drawing, be careful to take notes about the values, light, and the time of day, as well as any other details you are likely to forget. Sometimes you may want to take the time to more fully render a facial feature, such as an eye, and try sketching each animal from several different angles. Remember that no matter how much time you spend observing a subject, the impression in your mind will surely fade with time, so be as thorough in your notes as you can.

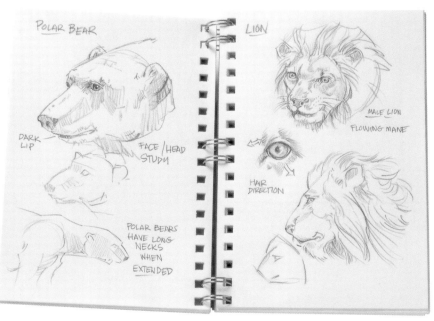

USING A VIEWFINDER

If you have a hard time deciding how to arrange the animal or animals on your paper, try looking through a viewfinder. You can form a double "L" with your fingers or use a cardboard frame, as shown below, and look through the opening. Bring the viewfinder closer and hold it out farther; move it around the scene; look at your subject from high and low viewpoints; and make the opening wider and narrower. Then choose the view that pleases you most.

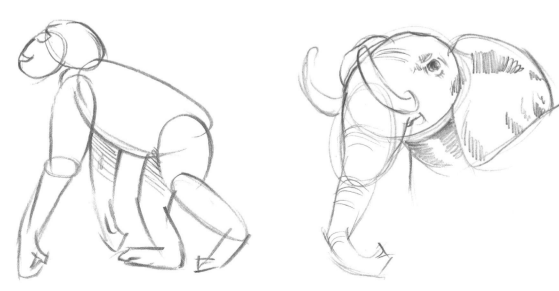

▲ **STARTING WITH BASIC SHAPES** Your sketches don't need to be as fully developed as the drawings shown in the sketchbook (above). Concentrate on training your eye to see your subject in terms of basic shapes—circles, ovals, rectangles, and triangles—and put them together in a rough drawing. For example, the sketch of the chimpanzee on the left started with a series of ovals, which were then connected with a few simple lines; the hands, feet, and facial features were merely suggested. The elephant portrait began with a circle, an oval, and roughly triangular shapes; from that point, it was easy to sketch out the shape of the trunk and place a few strokes for shading to hint at the elephant's form.

DRAWING ANIMALS IN ACTION

Sketching active animals

is a great exercise for both beginning and experienced artists because it requires the artist to observe and record as much information as possible in a short amount of time. Because active animals—such as these otters and spider monkeys—are almost constantly in motion, you must stroke quickly and learn to focus only on capturing the general movement and salient features. Apply swift pencil marks with long, sweeping strokes, and add only a few lines to the shadows to suggest form. Don't be afraid to try a variety of poses—a monkey in mid-jump may seem like a challenge, but you can end up with a captivating image that inspires you to challenge yourself even more. And remember that the more you practice, the faster you will become and the more adept you will be at depicting animals in action!

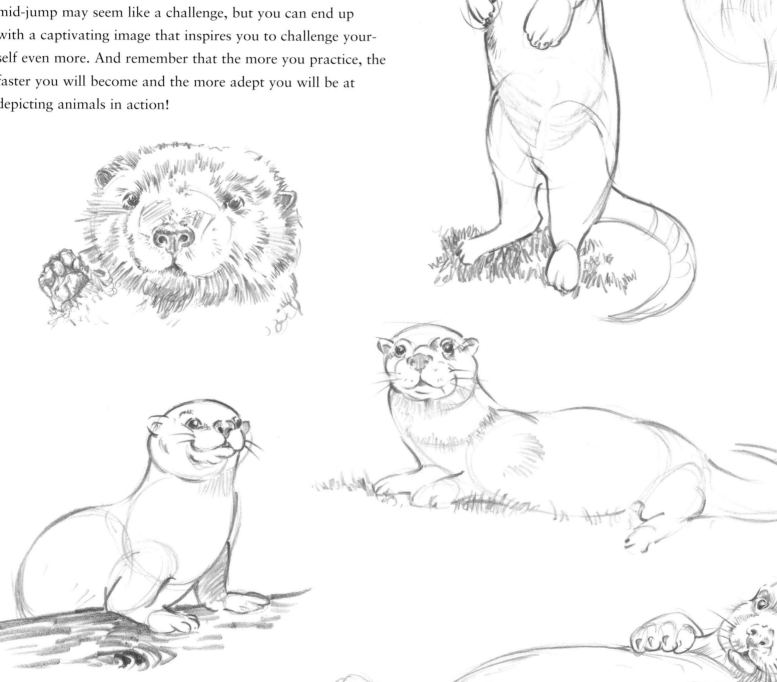

OTTERS To begin sketching these otters, use loose, lightly drawn circles to form the basic shapes of the head and body. From these rough lines, you can more easily determine where to place the limbs and tail. Once you establish the general bulk of the otter on paper, begin to add details, such as facial features, shadows, and claws.

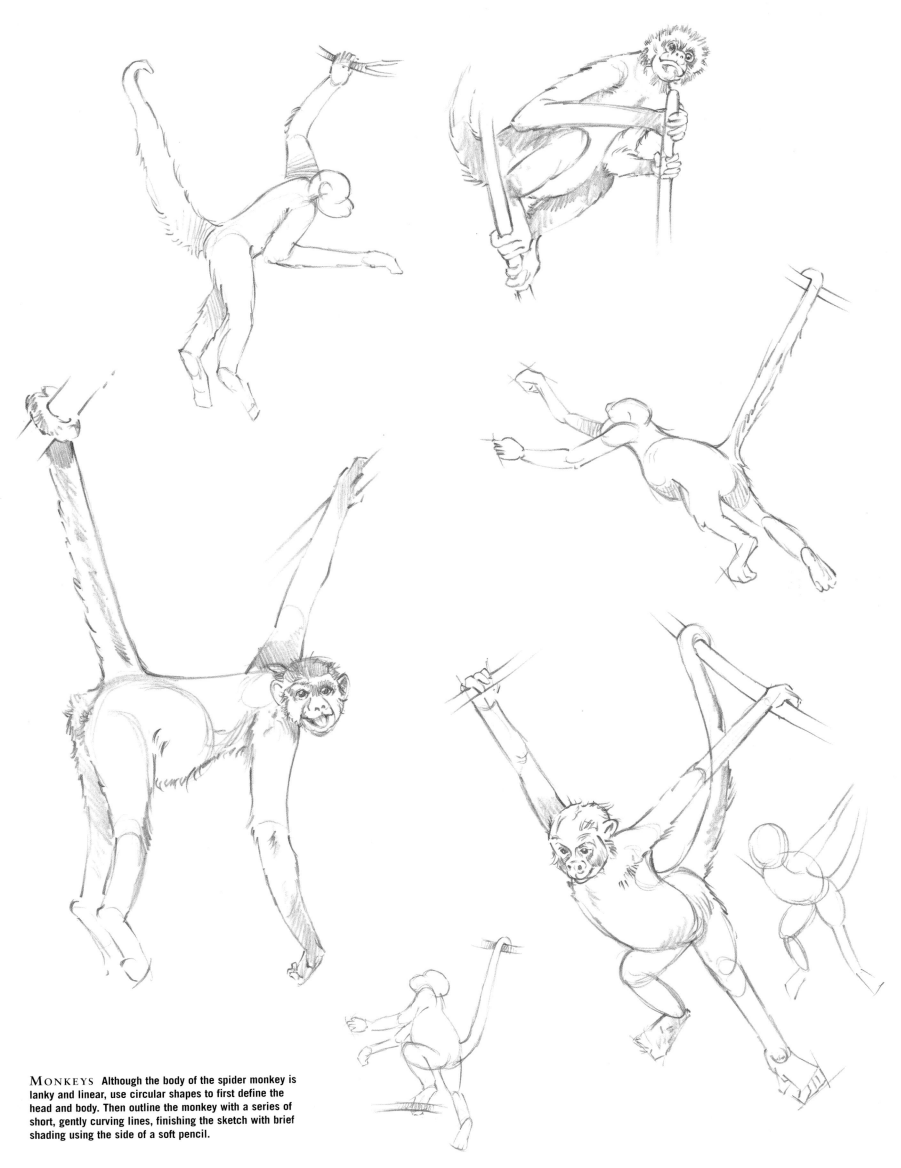

MONKEYS Although the body of the spider monkey is lanky and linear, use circular shapes to first define the head and body. Then outline the monkey with a series of short, gently curving lines, finishing the sketch with brief shading using the side of a soft pencil.

FLAMINGO

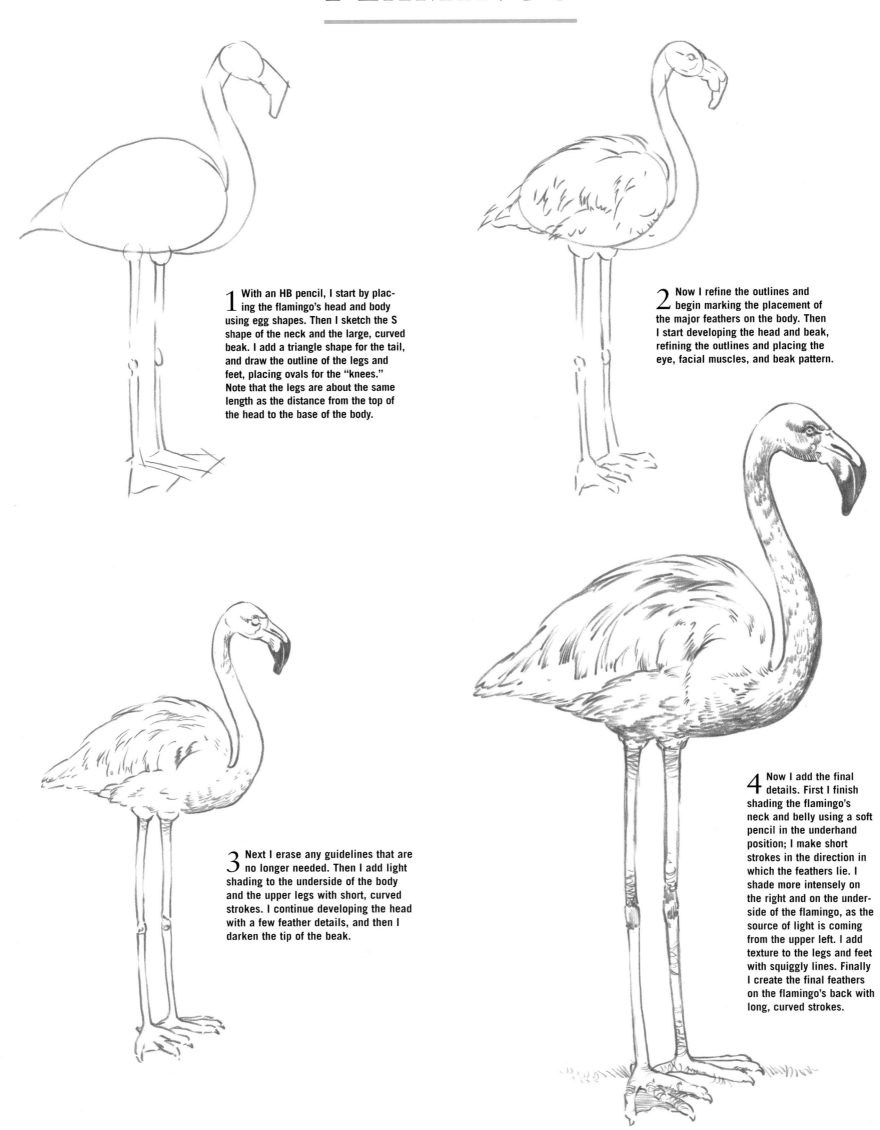

1 With an HB pencil, I start by plac-ing the flamingo's head and body using egg shapes. Then I sketch the S shape of the neck and the large, curved beak. I add a triangle shape for the tail, and draw the outline of the legs and feet, placing ovals for the "knees." Note that the legs are about the same length as the distance from the top of the head to the base of the body.

2 Now I refine the outlines and begin marking the placement of the major feathers on the body. Then I start developing the head and beak, refining the outlines and placing the eye, facial muscles, and beak pattern.

3 Next I erase any guidelines that are no longer needed. Then I add light shading to the underside of the body and the upper legs with short, curved strokes. I continue developing the head with a few feather details, and then I darken the tip of the beak.

4 Now I add the final details. First I finish shading the flamingo's neck and belly using a soft pencil in the underhand position; I make short strokes in the direction in which the feathers lie. I shade more intensely on the right and on the under-side of the flamingo, as the source of light is coming from the upper left. I add texture to the legs and feet with squiggly lines. Finally I create the final feathers on the flamingo's back with long, curved strokes.

ELEPHANT

1 I begin drawing the elephant with large overlapping circles and ovals to place the elephant's head and establish the general bulk of the body.

2 Next I draw thin, vertical ovals to indicate the legs and the widest part of the trunk. Then I draw the curved shapes of the tusks on either side of the base of the trunk.

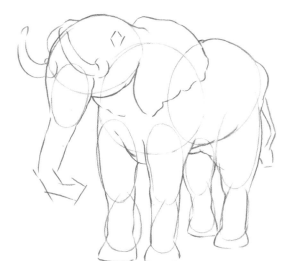

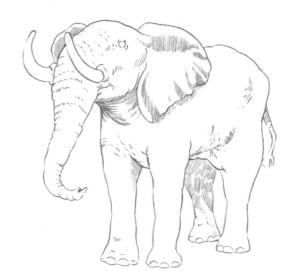

3 Now, using the basic shapes as a guide, I draw the outline of the elephant's body, ears, head, and legs as shown. Then I sketch the shape of the trunk and the general outline of the tail.

4 Now I refine the outlines and erase any guidelines that remain. Then I apply shading to the neck, ears, tail, and legs, reserving the darkest applications for the final step. I use short strokes to suggest the wrinkles on the trunk and some folds of skin on the body.

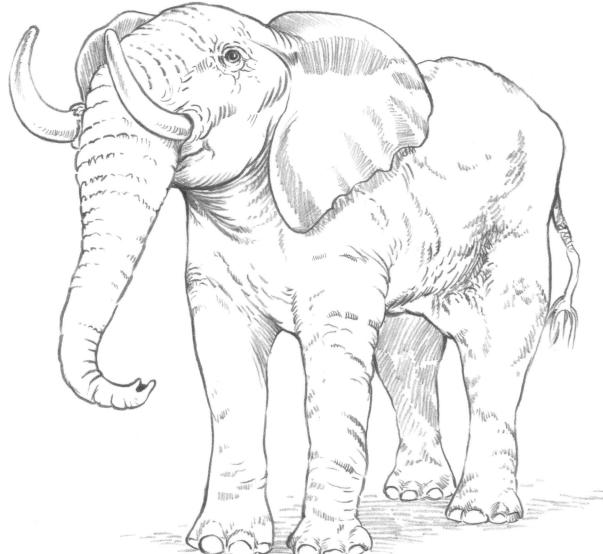

5 Using a 2B pencil, I reinforce the darkest shadows, such as on the tail and beneath the head. Then I fill in the detail of the eye, leaving a small spot unshaded for the highlight. Finally I finish developing the shading and texture of the elephant, and then I add a light cast shadow around the feet to anchor the elephant to the ground.

PENGUINS

1 Using an HB pencil, I sketch the body and head of each
penguin with ovals, tilting the positions of the bodies. I
arrange them in a U-shaped formation rather than in a straight
line to lead the viewer's eye through and around the drawing.

2 Now I add the beaks with simple curved and straight
lines, placing them to the right of the center of each
head. I also add the short legs and the shapes of the wide,
webbed feet. Then I add a few lines to establish the ground.

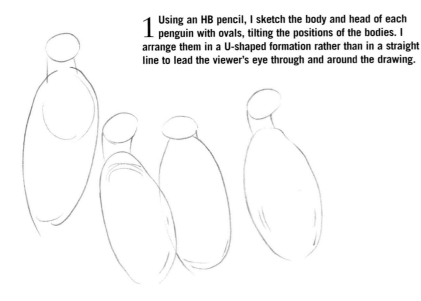

3 Next I add the eyes and place the wings and tails,
shading with parallel strokes and a round-pointed 2B
pencil. I also add some thin, curving lines beneath their
feet to begin developing the ground surface.

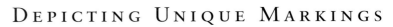

DEPICTING UNIQUE MARKINGS

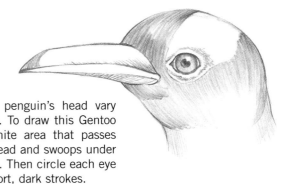

The markings on a penguin's head vary
according to species. To draw this Gentoo
penguin, leave a white area that passes
over the top of the head and swoops under
and around each eye. Then circle each eye
with a thin rim of short, dark strokes.

4 To finish, I shade the heads and tips of
the beaks with parallel strokes with the
2B pencil. I also add a bit of shading to the
upper legs of the penguins, and I place a
few strokes to add shadows to the ground.

ANTELOPE

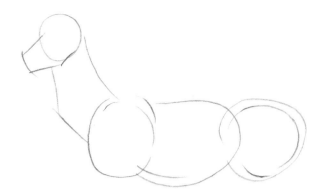

1 First I establish the placement of the antelope's head, muzzle, neck, chest, torso, and rear end. I don't sketch in the legs at this step so that I can assess the proportions of the head and body before moving on.

DETAILING THE HORNS

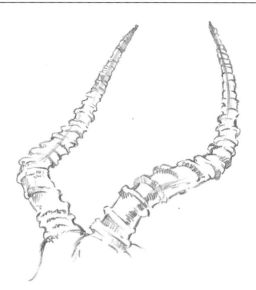

The horns of this antelope have several ridges from the base to the tip that produce a horizontal band pattern. Begin by indicating the bands with marks that wrap around the horns, and then add a small shadow beneath each ridge.

2 Now I add the front and back legs, making them the same height as the distance from the top of the head to the bottom of the chest. I use the circles that indicate the chest and rear sections to determine the placement of the legs.

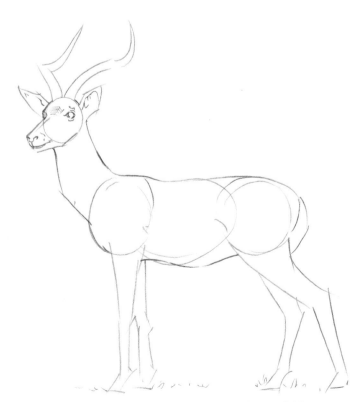

4 I add a few patches of shading to indicate form on the face, horns, and body. I also add shadows to the areas where the light does not hit, such as on the antelope's underside and upper areas of the far legs. Then I apply the final details to the horns, ears, and eyes, adding a little more grass to complete the drawing.

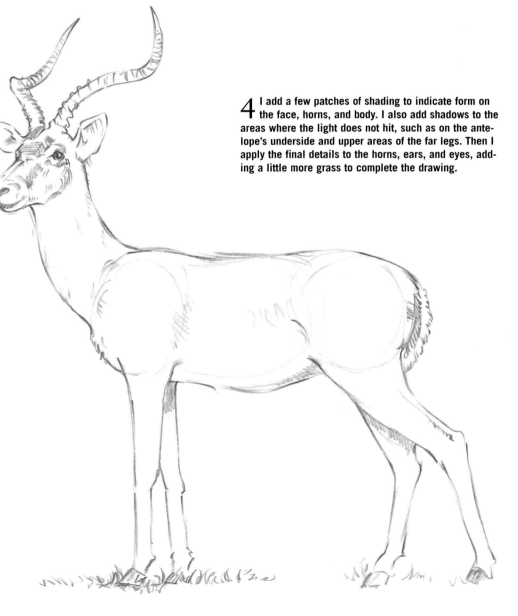

3 Next I refine the outline of the body, connecting the initial shapes with a smooth contour. I also lightly sketch in blades of grass and mark the position of the eyes, nose, mouth, and horns, adjusting their placements until I am satisfied with the proportions.

POLAR BEAR

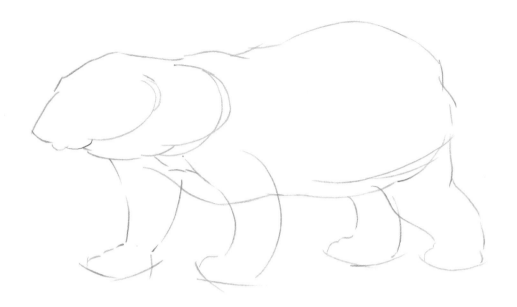

1 I begin by sketching the general outlines of the body, head, and legs of the polar bear, paying careful attention to proportions. I draw a few lines to indicate the length of the massive neck and two quick strokes for his chest. Notice that the head is slightly lower than the rear, and that the front legs curve slightly inward.

2 Next I add the ears with two concentric semi-circles and block in the squarish nose. I also sketch the outline of the thick ice floe beneath the bear's feet. I start with an irregular half-oval and then draw a matching line beneath it, connecting the top and the base with vertical lines.

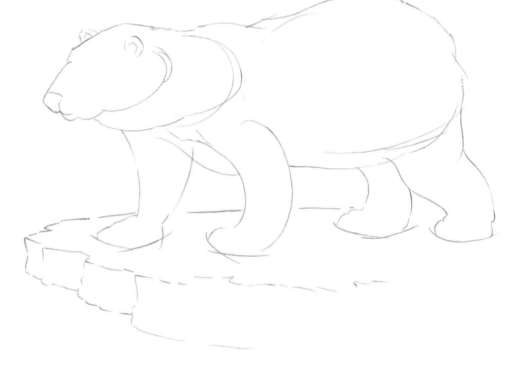

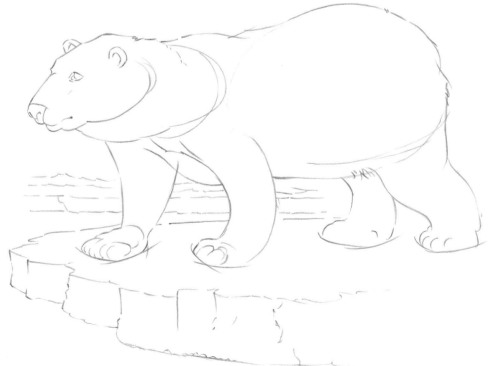

3 Now I place the eye and begin building the form of the feet with circular strokes. To suggest the mass of ice in the background, I add four broken horizontal lines behind the ice floe.

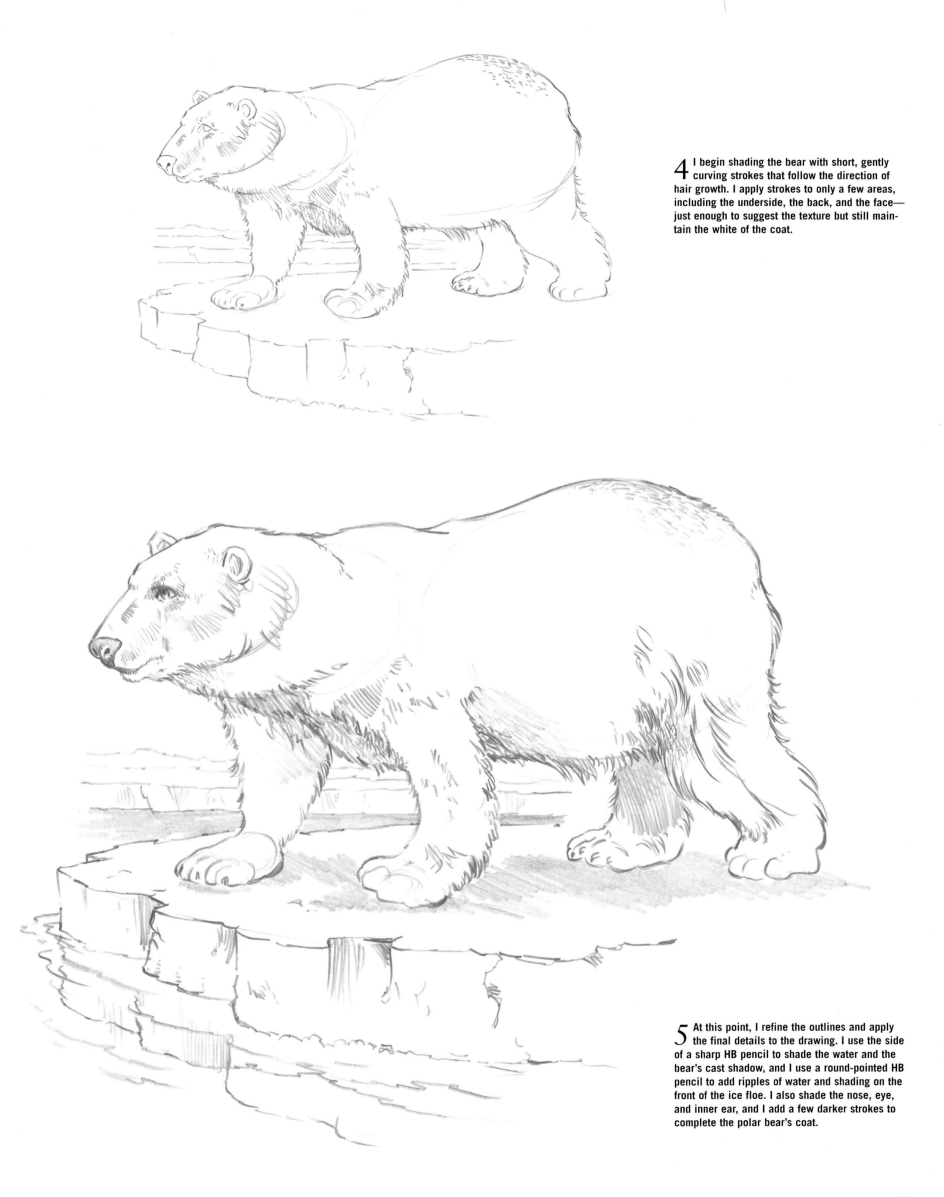

4 I begin shading the bear with short, gently curving strokes that follow the direction of hair growth. I apply strokes to only a few areas, including the underside, the back, and the face—just enough to suggest the texture but still maintain the white of the coat.

5 At this point, I refine the outlines and apply the final details to the drawing. I use the side of a sharp HB pencil to shade the water and the bear's cast shadow, and I use a round-pointed HB pencil to add ripples of water and shading on the front of the ice floe. I also shade the nose, eye, and inner ear, and I add a few darker strokes to complete the polar bear's coat.

BABOON

1 I block in the inquisitive pose of this baboon using a sharp HB pencil. I begin with the general shape of the head, placing guidelines for the main features. Next I sketch the round line of the body and roughly block in the shapes of the legs and arms. Then I place the curves of the tail.

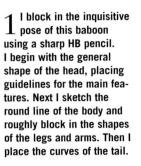
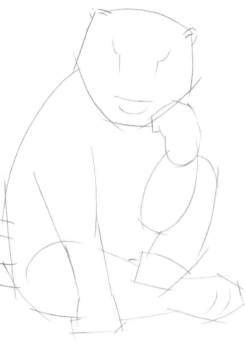

2 Without further developing the outline, I start adding the facial features. I use a dull HB pencil to shade around the eyes and nose, always stroking in the direction in which the hair grows. I also start to refine the outlines of the hands and feet, indicating the individual fingers and toes.

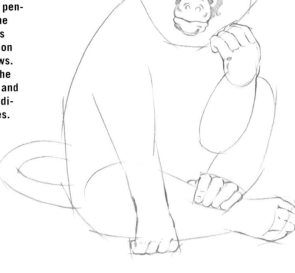

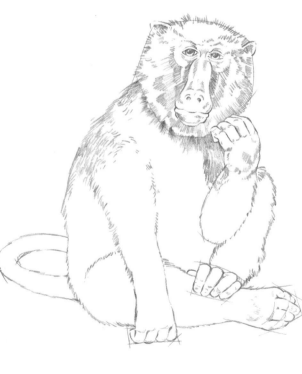

3 I continue to develop the coat texture around the face and on the back. Because the baboon is covered in hair, I choose to leave out any harsh outlines. Instead I apply a series of short, parallel strokes that follow the initial outlines from step one.

4 I finish developing the shading on the body, adding strokes to the darkest areas of the baboon but leaving the lightest areas completely white. Finally I add a cast shadow to the ground beneath the baboon with the flattened point of an HB pencil.

KANGAROO

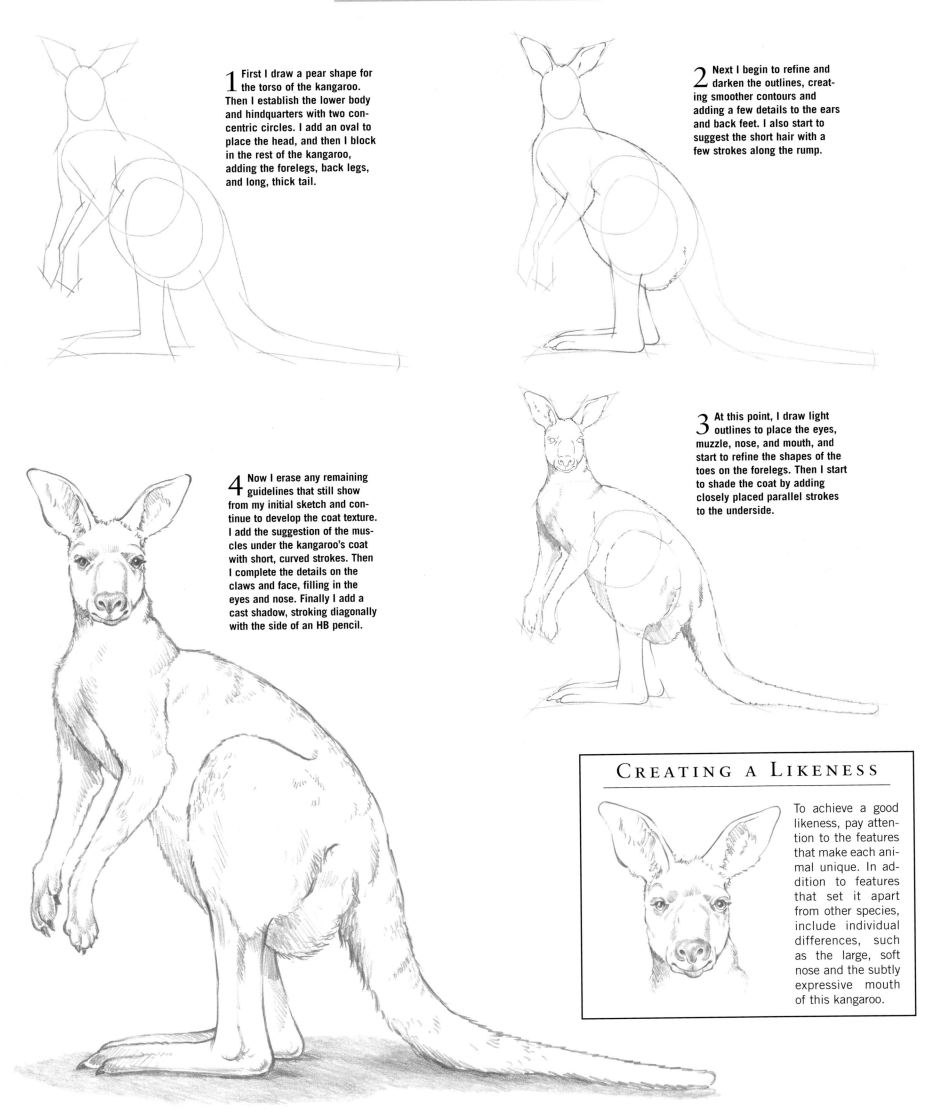

1 First I draw a pear shape for the torso of the kangaroo. Then I establish the lower body and hindquarters with two concentric circles. I add an oval to place the head, and then I block in the rest of the kangaroo, adding the forelegs, back legs, and long, thick tail.

2 Next I begin to refine and darken the outlines, creating smoother contours and adding a few details to the ears and back feet. I also start to suggest the short hair with a few strokes along the rump.

3 At this point, I draw light outlines to place the eyes, muzzle, nose, and mouth, and start to refine the shapes of the toes on the forelegs. Then I start to shade the coat by adding closely placed parallel strokes to the underside.

4 Now I erase any remaining guidelines that still show from my initial sketch and continue to develop the coat texture. I add the suggestion of the muscles under the kangaroo's coat with short, curved strokes. Then I complete the details on the claws and face, filling in the eyes and nose. Finally I add a cast shadow, stroking diagonally with the side of an HB pencil.

CREATING A LIKENESS

To achieve a good likeness, pay attention to the features that make each animal unique. In addition to features that set it apart from other species, include individual differences, such as the large, soft nose and the subtly expressive mouth of this kangaroo.

GIRAFFE

1 To begin, I block in the shape of the giraffe, adjusting the lines until I am satisfied with the proportions. Notice that the giraffe's neck is as long as its legs, and its hindquarters slope sharply.

2 Now I begin to refine the shapes of the legs and rump, smoothing the giraffe's outline. Then I begin placing the features and blocking in the patched pattern of its coat. For this species of giraffe, the spots all have slightly different irregular shapes, with small gaps between them.

3 Now I erase any stray sketch marks and focus my attention on rendering the giraffe's face. (See the details in the box below.) Then I fill in all the dark patches of the coat, adding the mane with a 2B pencil and short, dense diagonal strokes.

DRAWING THE HEAD

Start with a circle for the head and two smaller circles for the muzzle; then add the horns and ears. Draw a curved jaw line, and sketch in the eyes—and eyelashes—and inner ear details. Then refine all the outlines and shade the face, using a soft pencil for the dark areas and changing the direction of the strokes to follow the forms.

4 In this final step, after shading the face to my satisfaction, I add the shading beneath the giraffe's body and head. To keep the giraffe from appearing to float on the page, I draw the ground with tightly spaced diagonal strokes.

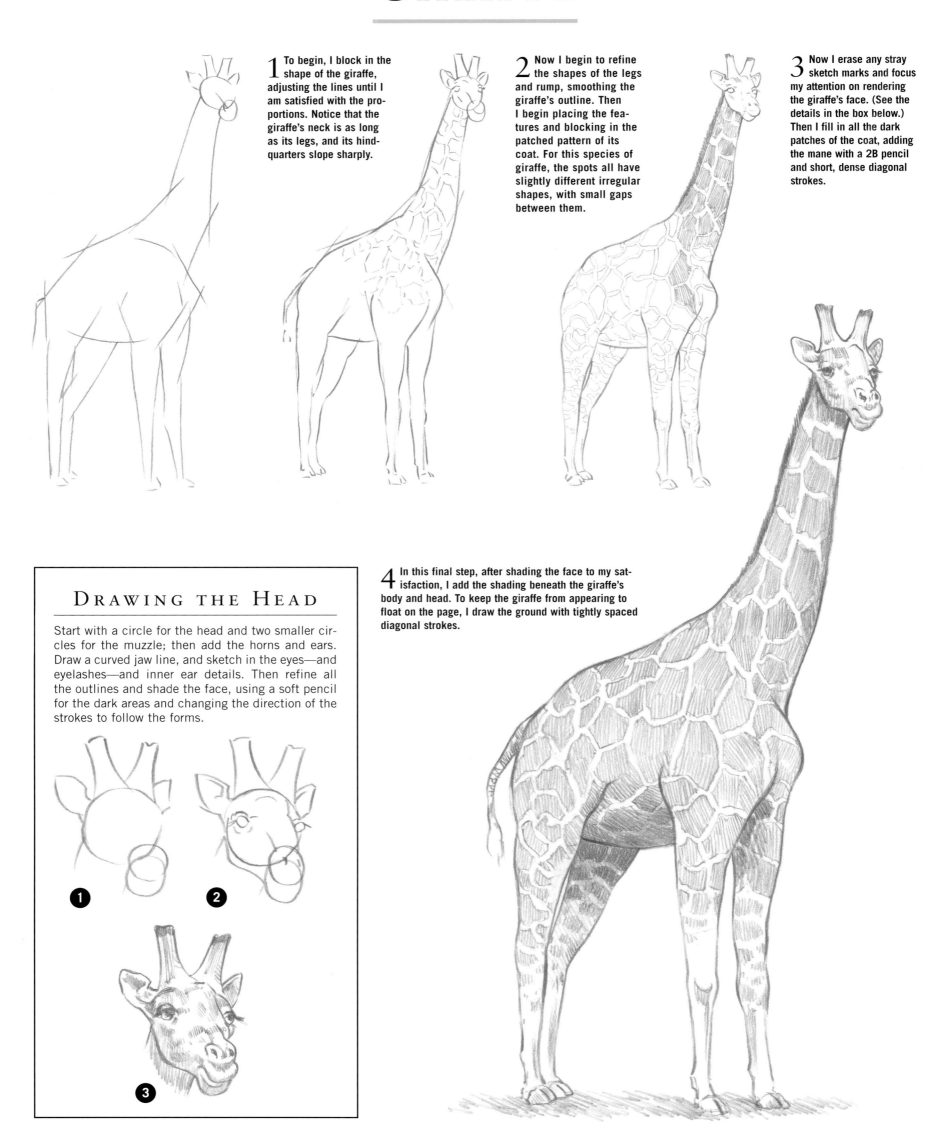

TOUCAN

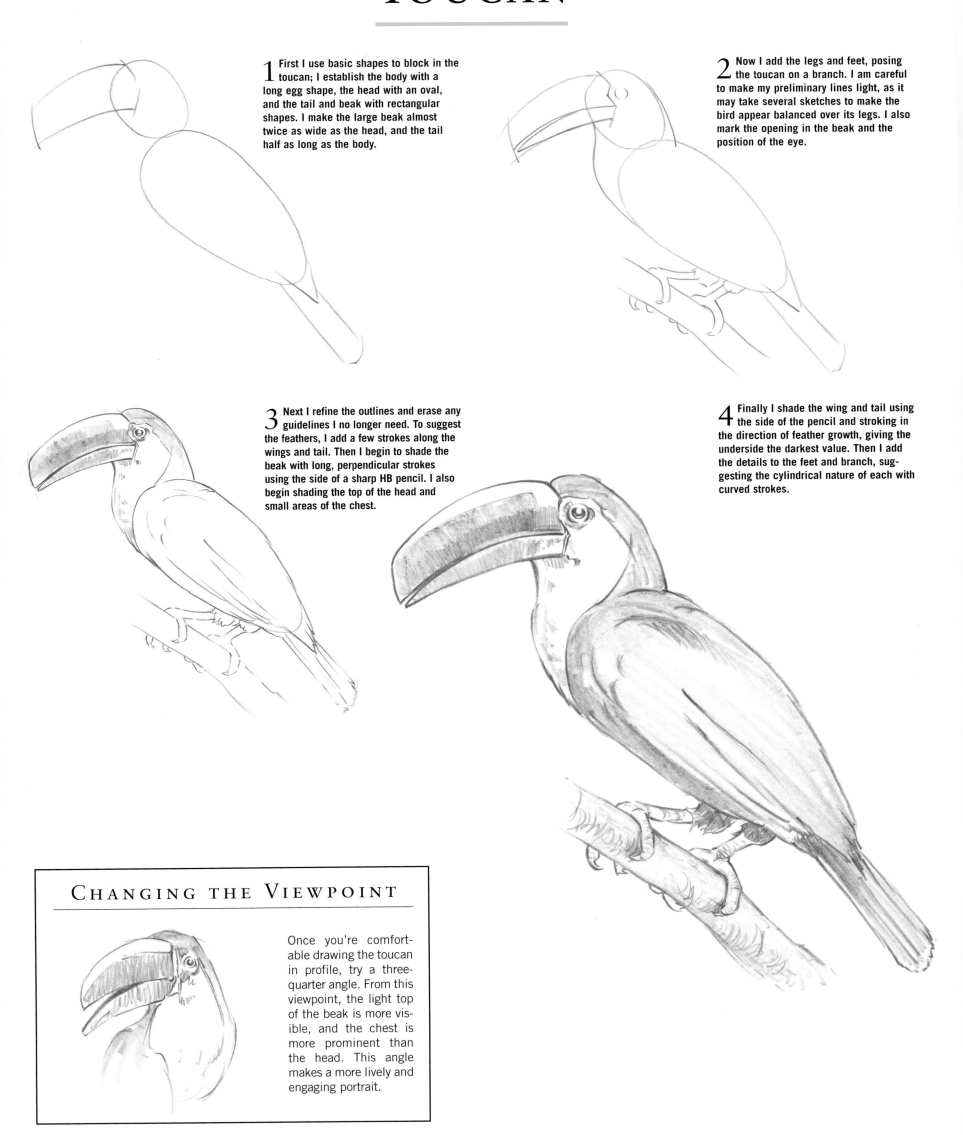

1 First I use basic shapes to block in the toucan; I establish the body with a long egg shape, the head with an oval, and the tail and beak with rectangular shapes. I make the large beak almost twice as wide as the head, and the tail half as long as the body.

2 Now I add the legs and feet, posing the toucan on a branch. I am careful to make my preliminary lines light, as it may take several sketches to make the bird appear balanced over its legs. I also mark the opening in the beak and the position of the eye.

3 Next I refine the outlines and erase any guidelines I no longer need. To suggest the feathers, I add a few strokes along the wings and tail. Then I begin to shade the beak with long, perpendicular strokes using the side of a sharp HB pencil. I also begin shading the top of the head and small areas of the chest.

4 Finally I shade the wing and tail using the side of the pencil and stroking in the direction of feather growth, giving the underside the darkest value. Then I add the details to the feet and branch, suggesting the cylindrical nature of each with curved strokes.

CHANGING THE VIEWPOINT

Once you're comfortable drawing the toucan in profile, try a three-quarter angle. From this viewpoint, the light top of the beak is more visible, and the chest is more prominent than the head. This angle makes a more lively and engaging portrait.

Lion

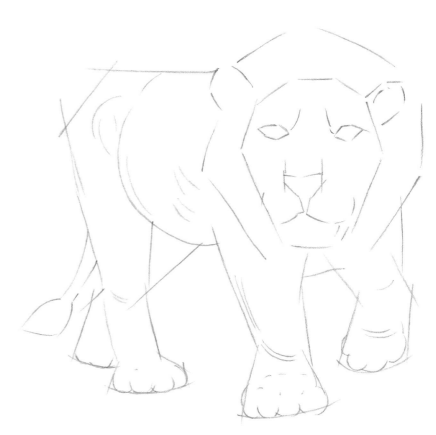

1 I begin by blocking in the basic shape of the lion with a series of short, rough lines. I use an HB pencil so that the markings are light enough to erase thoroughly. I adjust the proportions as much as is needed before moving on.

2 Now, using the same pencil, I sketch the position of the eyes, nose, and mouth. Note that the top of the nose is about halfway down the face, and the eyes are about one third of the way down. Then I begin to indicate the lion's form by marking a few lines near the leg joints and on his side; these marks will later serve as guides for shading.

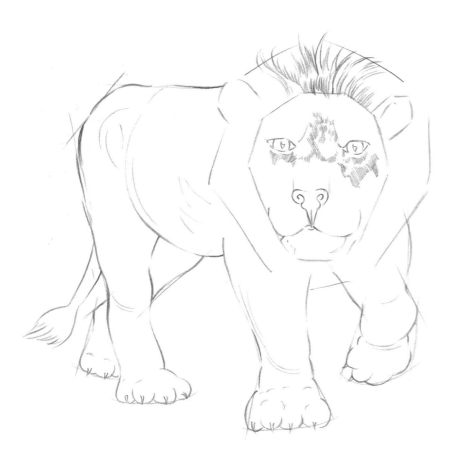

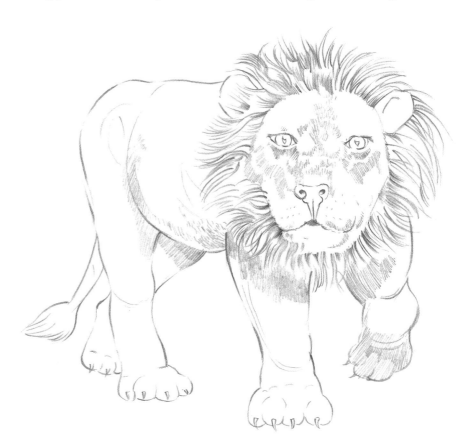

3 Next I start refining the outlines of the lion's body and legs by rounding out the sharp corners. For the mane, I begin adding the hair with curved lines, stroking from the edge of the lion's face outward. I also begin to shade the lion's face, applying small patches of parallel strokes.

4 I continue to develop the lion's mane, placing the strokes close together and changing the values by altering the amount of pressure I apply on the pencil. This variation in value gives the mane a sense of dimension with a minimum number of strokes. I now erase any initial sketch marks I no longer need and continue to develop the shading on the face. I also begin to add shading to other areas of the body, including the belly, the upper back, the front legs, and the lifted paw.

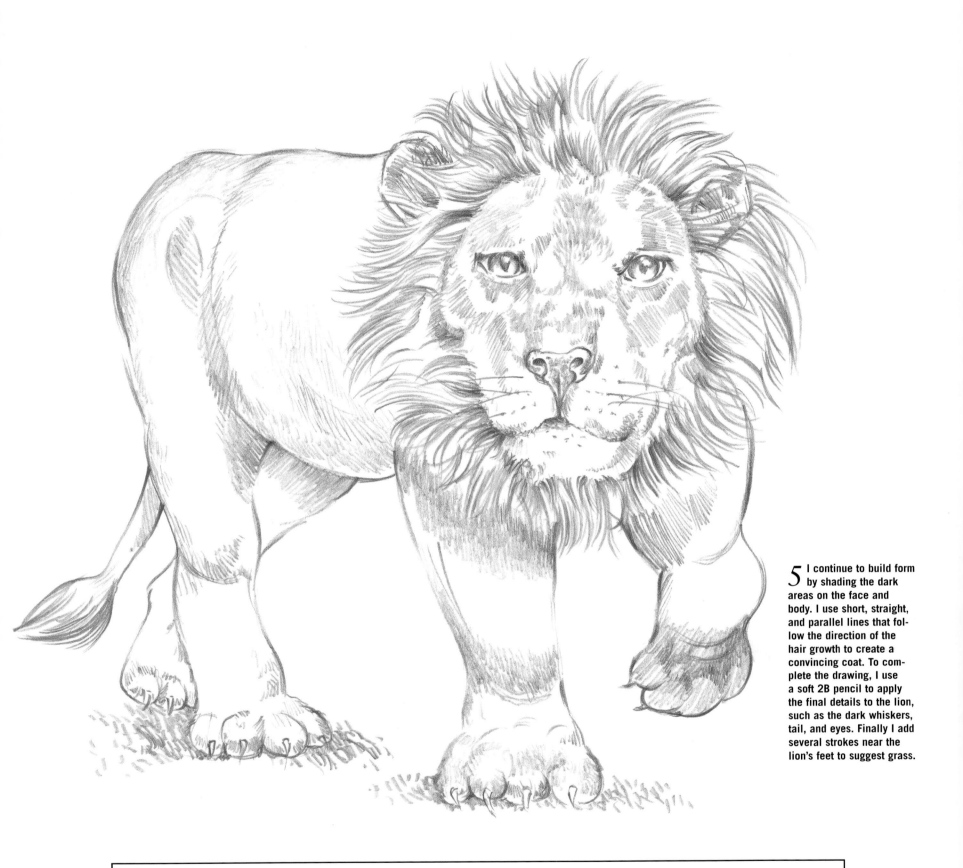

5 I continue to build form by shading the dark areas on the face and body. I use short, straight, and parallel lines that follow the direction of the hair growth to create a convincing coat. To complete the drawing, I use a soft 2B pencil to apply the final details to the lion, such as the dark whiskers, tail, and eyes. Finally I add several strokes near the lion's feet to suggest grass.

COMPARING THE MALE AND FEMALE

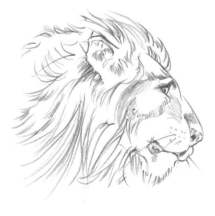

The male lion has a larger head than the female, accentuated by the presence of a shaggy mane. The lion also has a broad face and large jaw, making him appear more threatening than the female.

The female lion lacks a mane, making her easy to distinguish from a male. Because of this absence, the head of the lioness appears slimmer with a sleeker look.

WOLF

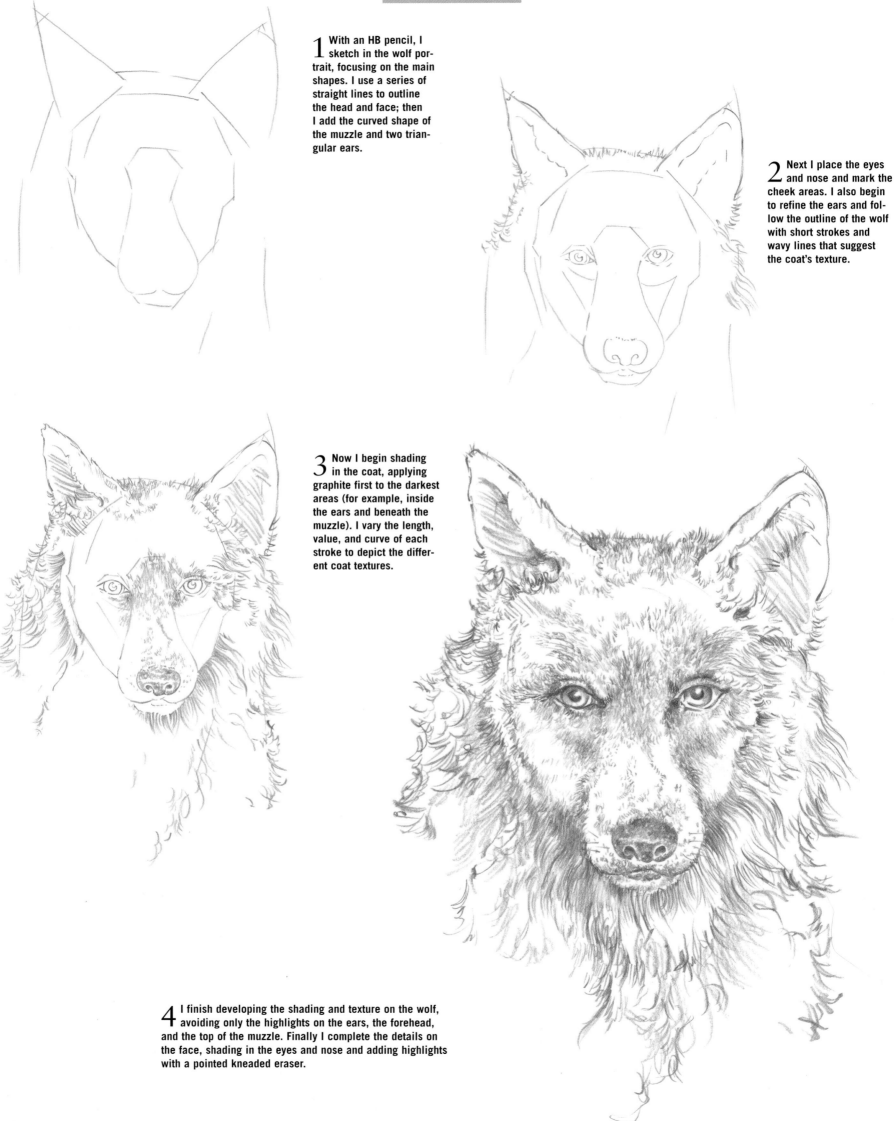

1 With an HB pencil, I sketch in the wolf portrait, focusing on the main shapes. I use a series of straight lines to outline the head and face; then I add the curved shape of the muzzle and two triangular ears.

2 Next I place the eyes and nose and mark the cheek areas. I also begin to refine the ears and follow the outline of the wolf with short strokes and wavy lines that suggest the coat's texture.

3 Now I begin shading in the coat, applying graphite first to the darkest areas (for example, inside the ears and beneath the muzzle). I vary the length, value, and curve of each stroke to depict the different coat textures.

4 I finish developing the shading and texture on the wolf, avoiding only the highlights on the ears, the forehead, and the top of the muzzle. Finally I complete the details on the face, shading in the eyes and nose and adding highlights with a pointed kneaded eraser.

PANDA

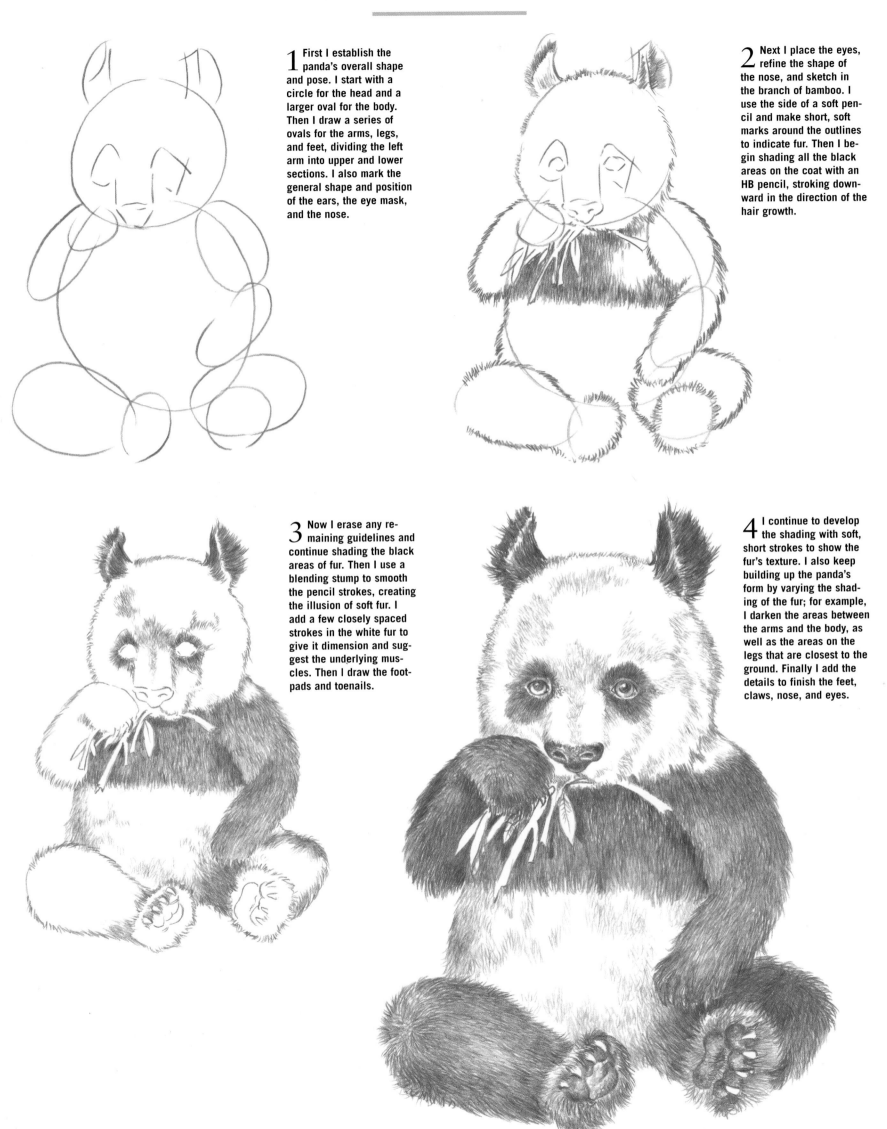

1 First I establish the panda's overall shape and pose. I start with a circle for the head and a larger oval for the body. Then I draw a series of ovals for the arms, legs, and feet, dividing the left arm into upper and lower sections. I also mark the general shape and position of the ears, the eye mask, and the nose.

2 Next I place the eyes, refine the shape of the nose, and sketch in the branch of bamboo. I use the side of a soft pencil and make short, soft marks around the outlines to indicate fur. Then I begin shading all the black areas on the coat with an HB pencil, stroking downward in the direction of the hair growth.

3 Now I erase any remaining guidelines and continue shading the black areas of fur. Then I use a blending stump to smooth the pencil strokes, creating the illusion of soft fur. I add a few closely spaced strokes in the white fur to give it dimension and suggest the underlying muscles. Then I draw the footpads and toenails.

4 I continue to develop the shading with soft, short strokes to show the fur's texture. I also keep building up the panda's form by varying the shading of the fur; for example, I darken the areas between the arms and the body, as well as the areas on the legs that are closest to the ground. Finally I add the details to finish the feet, claws, nose, and eyes.

GALAPAGOS TORTOISE

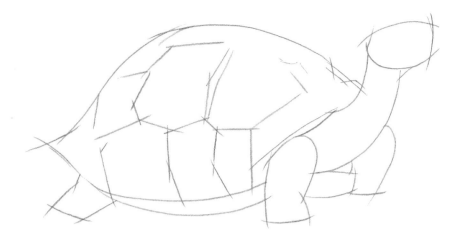

1 First I sketch the roughly oval shape of the tortoise shell and body with an HB pencil. Then I draw an egg shape for the head and sketch in the curved neck and stocky legs. I also add rough lines to indicate the general pattern of the shell.

2 Next I refine the outlines, giving the shell a bumpy perimeter and smoothing the lines of the legs, head, and neck. Then I mark the positions of the eye, mouth, and toes and sketch the round segments on the shell just beneath the tortoise's neck.

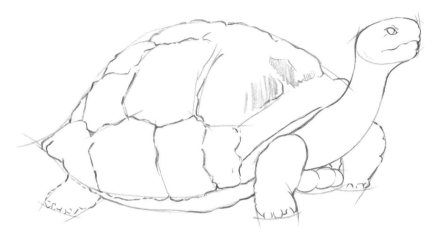

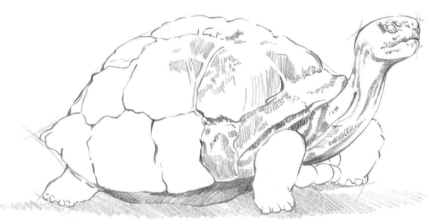

3 Now I begin to develop the shading on the shell with light, parallel strokes. I also begin shading the neck with patches of short strokes stretching from the shell toward the head, giving the skin a dry, wrinkled look. Then I darken the underside of the tortoise and add a light cast shadow with the side of a soft pencil.

4 I continue to apply light shading to the shell, varying the direction of my strokes and leaving plenty of white on the light-colored shell. I also develop the texture of the legs and add dimension to the toenails. Then I fill in the eye, leaving a highlight in the upper-right quadrant.

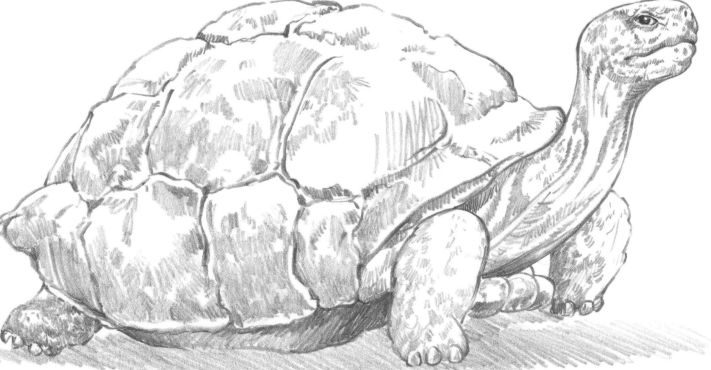

RATTLESNAKE

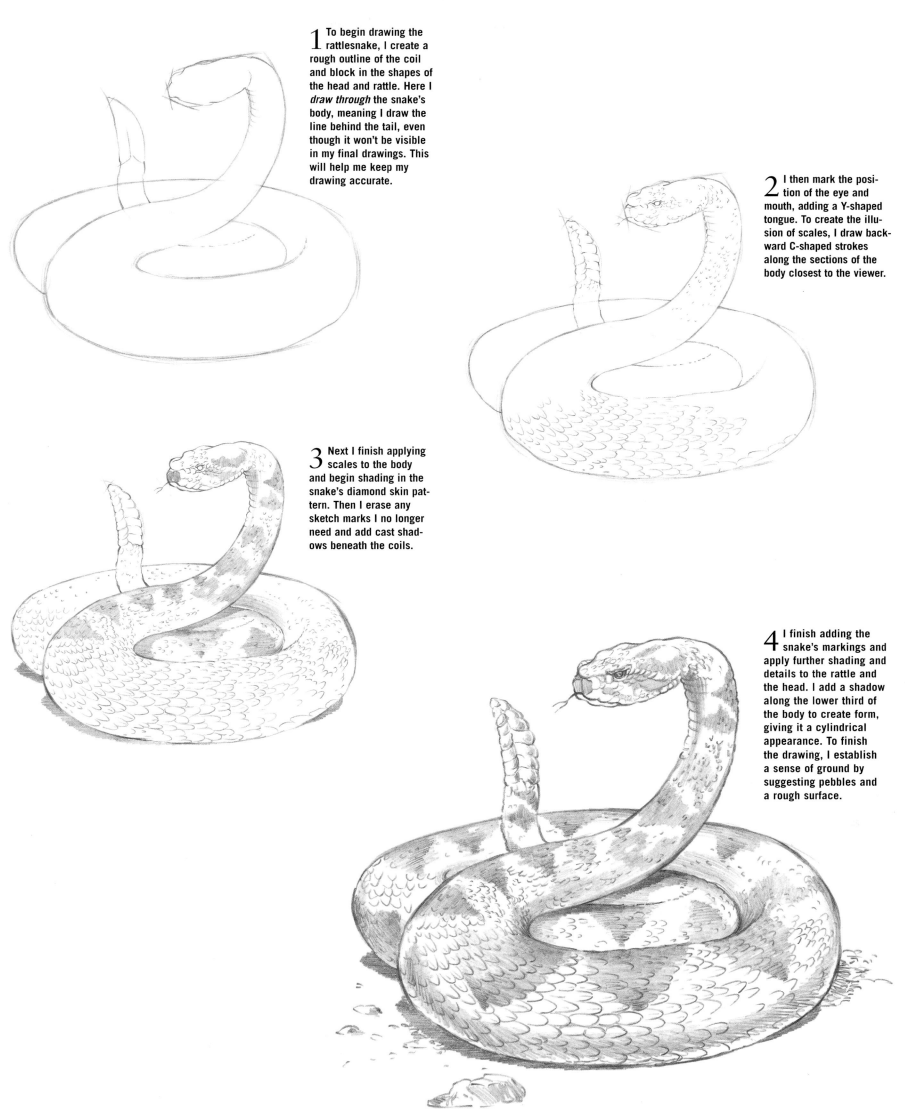

1 To begin drawing the rattlesnake, I create a rough outline of the coil and block in the shapes of the head and rattle. Here I *draw through* the snake's body, meaning I draw the line behind the tail, even though it won't be visible in my final drawings. This will help me keep my drawing accurate.

2 I then mark the position of the eye and mouth, adding a Y-shaped tongue. To create the illusion of scales, I draw backward C-shaped strokes along the sections of the body closest to the viewer.

3 Next I finish applying scales to the body and begin shading in the snake's diamond skin pattern. Then I erase any sketch marks I no longer need and add cast shadows beneath the coils.

4 I finish adding the snake's markings and apply further shading and details to the rattle and the head. I add a shadow along the lower third of the body to create form, giving it a cylindrical appearance. To finish the drawing, I establish a sense of ground by suggesting pebbles and a rough surface.

BISON

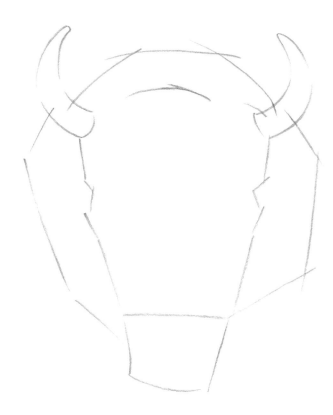

1 I begin by using an HB pencil with a rounded point to sketch the rough shapes of the bison's face, horns, and mane. As this is a straight-on portrait, I am careful to make this early composition as symmetrical as possible. I mark for indentations just below the eyes and square off the face where the "beard" begins.

2 Now I block in the structure of the face, indicating the different planes of the muzzle and the slope of the forehead. I will later use these lines as guides for shading, eliminating the hard lines by softening them with short, parallel pencil strokes.

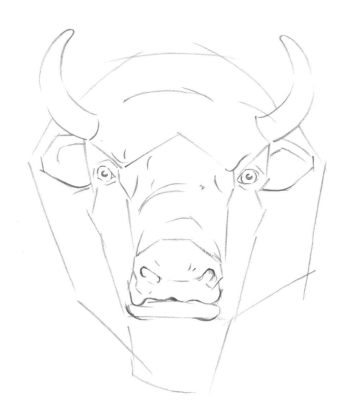

3 Next I add the facial features, including the eyes, ears, and nostrils. I place the ears just below the base of the horns, and I place the eyes level with the bottom half of the ears. Note that the eyes are extremely far apart; they should be placed slightly wider than the corners of the mouth. Then I begin refining the outline of the nostrils and mouth.

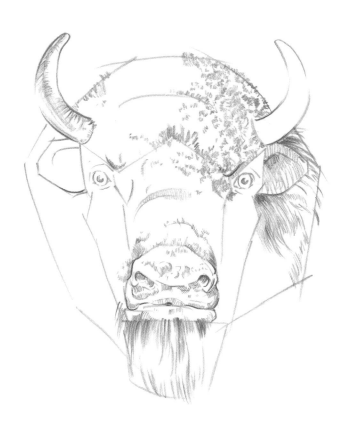

4 Now I begin shading the bison, suggesting various textures. For the flowing hair beneath the mouth, I use long, slightly wavy lines that are heaviest at the base of the chin. To suggest a shorter, curlier coat on the face and the top of the head, I use the side of a round-tipped pencil to apply several short strokes and squiggles. I also begin shading the horns with curved lines that follow the cylindrical form.

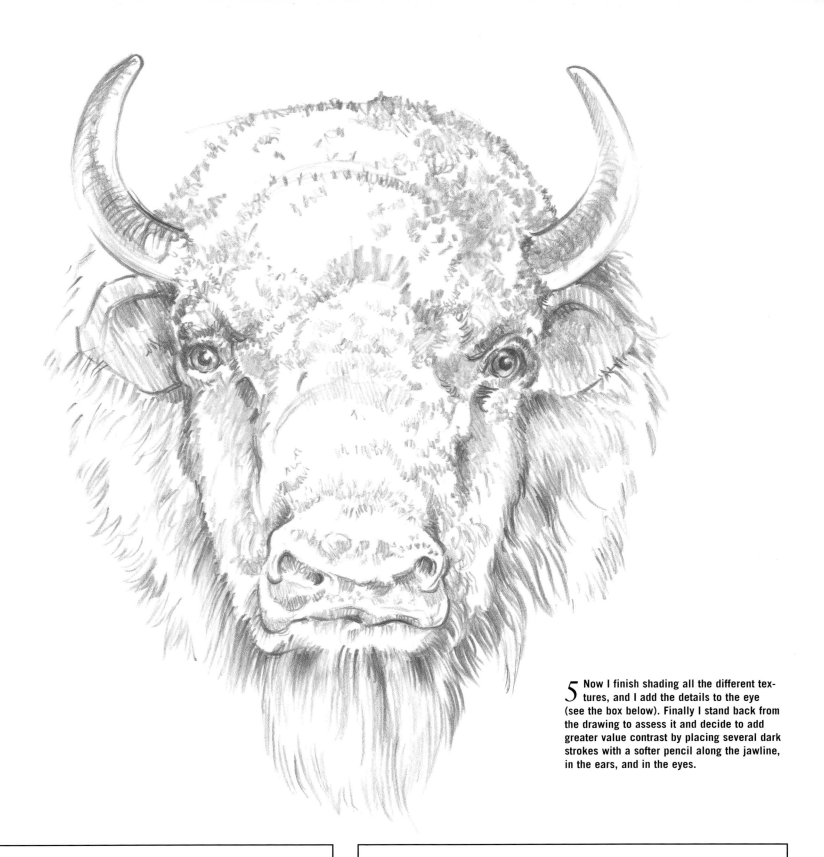

5 Now I finish shading all the different textures, and I add the details to the eye (see the box below). Finally I stand back from the drawing to assess it and decide to add greater value contrast by placing several dark strokes with a softer pencil along the jawline, in the ears, and in the eyes.

EXAMINING THE BODY

From the side, the bison has a flat profile, an extremely low head, short front legs, and a high set of shoulders that give it a rough and almost primitive appearance.

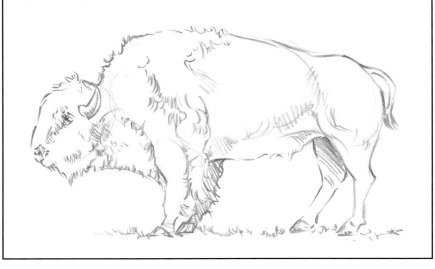

DRAWING EYES

I begin by outlining the eyelid, iris, pupil, and brow with light, thin lines. Then I indicate the darkest values by filling in the pupil and part of the iris, leaving a white highlight. I continue to develop the eye's form with shading, and I rub a tortillon over areas of the eyeball to soften the highlights and diminish any harsh edges.

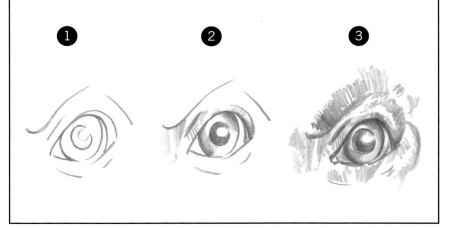

CHIMPANZEES

1 With circular strokes and a sharp HB pencil, I build the basic form of each chimp's body. Note that—unlike humans—chimpanzees have longer arms than legs.

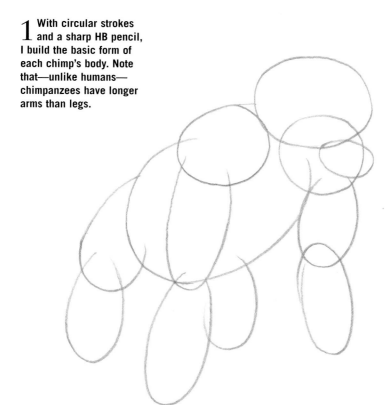

2 Next I block in the feet and hands with straight lines. I also mark the placement of the facial features, sketching in the outlines of the mouth, eyes, brow, and ears.

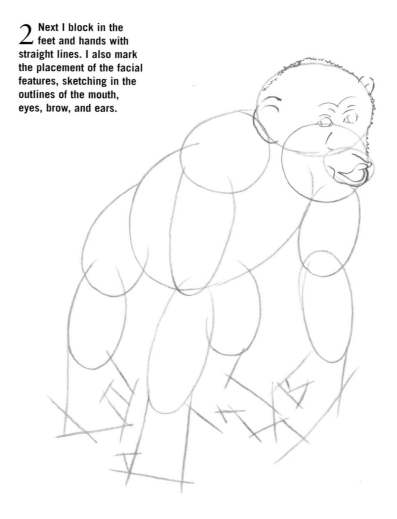

3 At this point, I soften the outlines of the chimps with uneven, curved strokes and dashes. The outlines should not be solid and smooth; they should suggest the hairy texture of the chimp's coat. I also draw the hands and feet inside the guidelines from step two.

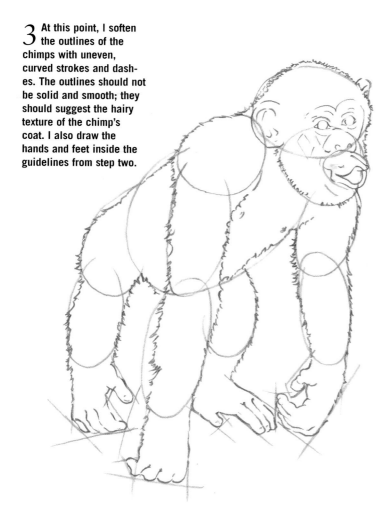

4 Now I erase any initial guidelines that still show, and I begin shading in the chimps' dark coats with a soft pencil. I apply short strokes that follow the direction of the hair growth, adding fewer lines to the highlighted areas and more to the shadows and creases.

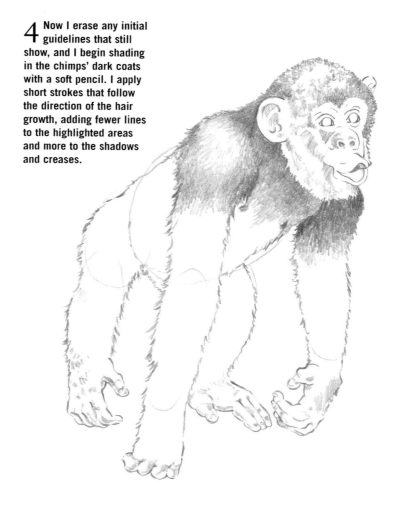

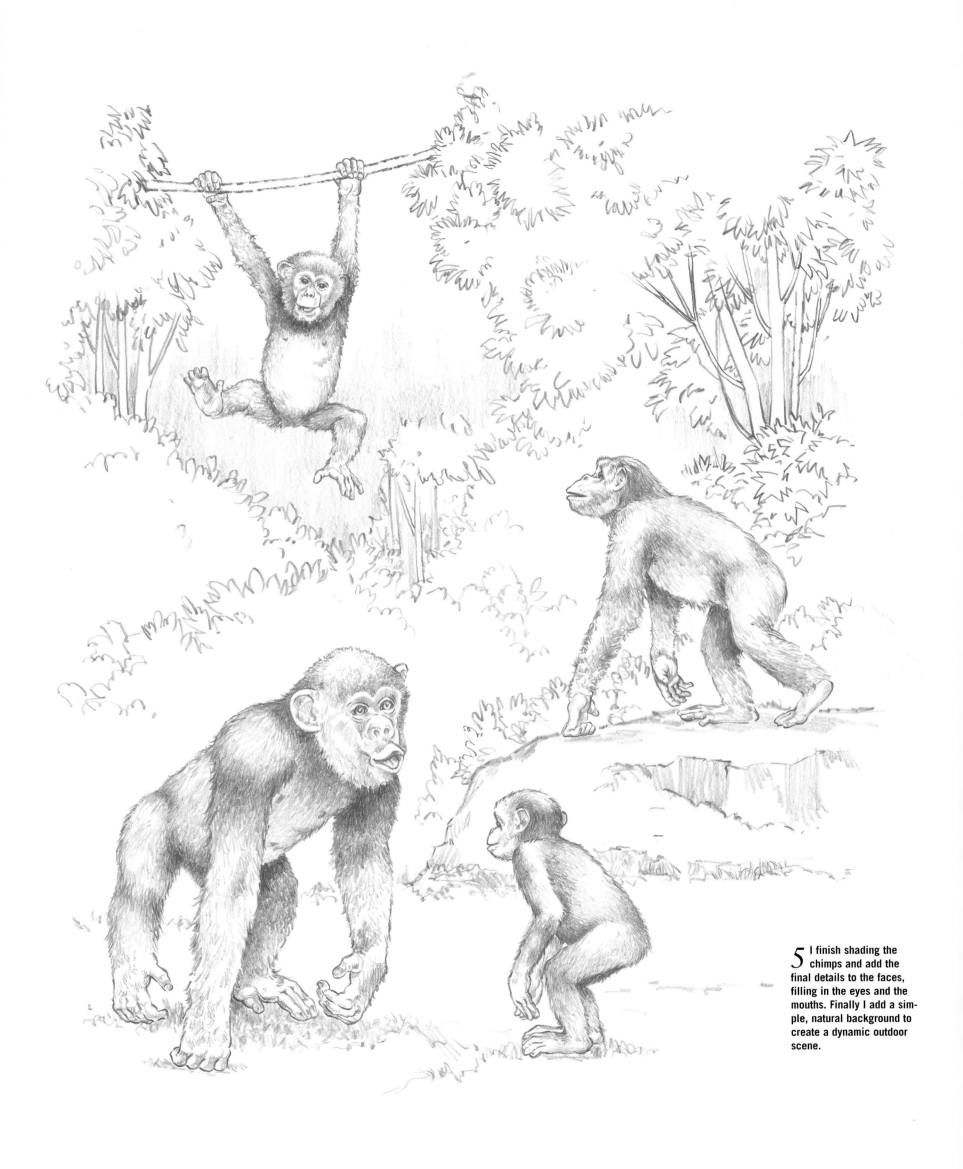

5 I finish shading the chimps and add the final details to the faces, filling in the eyes and the mouths. Finally I add a simple, natural background to create a dynamic outdoor scene.

KOALAS

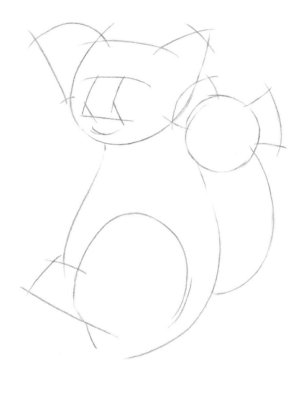

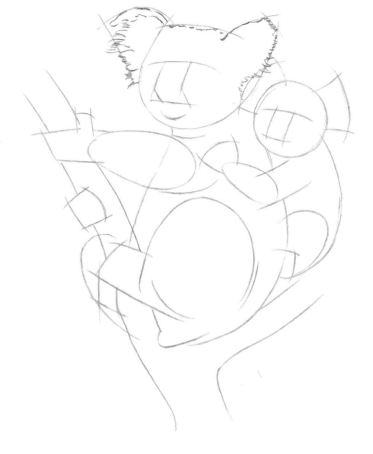

1 First I block in the shapes of the bodies and heads of the two koalas with an HB pencil, making the baby's head larger in proportion to its body than the adult's head is. Then I draw a few guidelines for placing the adult koala's facial features.

2 Next I add the limbs and the guidelines for the baby's face, and I perch the koalas between two branches of a eucalyptus tree. Once the entire composition is blocked in, I use a series of curved, horizontal strokes to indicate furry ears along the outline of the head.

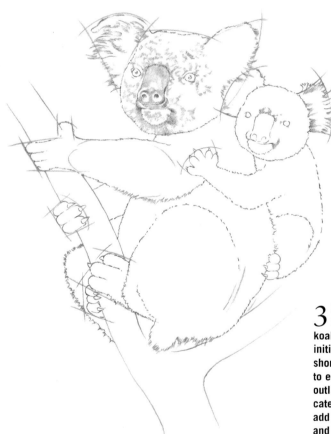

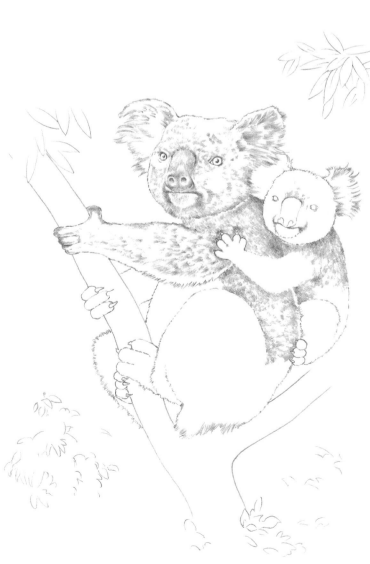

3 I complete the outline of the koalas, retracing the initial sketch with short, broken marks to eliminate any hard outlines and to replicate the soft fur. I also add the facial features and begin shading the adult's face, making the nose a darker value and an even tone to distinguish it from the fuzzier surrounding fur.

4 Now I start developing the coat texture of the koala using a very sharp HB pencil. I apply small patches of short strokes over the bodies of the koalas to produce a velvety texture, applying more pressure and using a greater number of strokes in the shadowed areas.

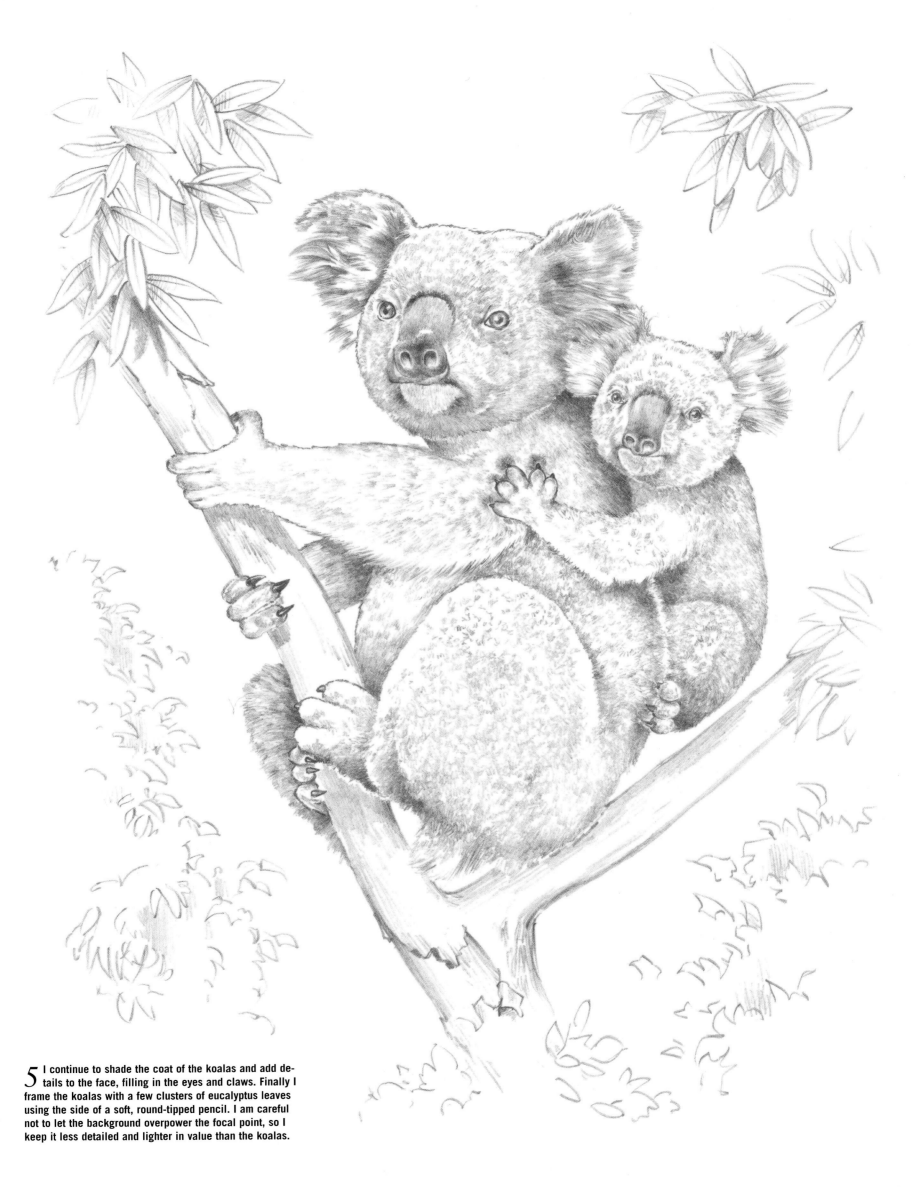

5 I continue to shade the coat of the koalas and add details to the face, filling in the eyes and claws. Finally I frame the koalas with a few clusters of eucalyptus leaves using the side of a soft, round-tipped pencil. I am careful not to let the background overpower the focal point, so I keep it less detailed and lighter in value than the koalas.

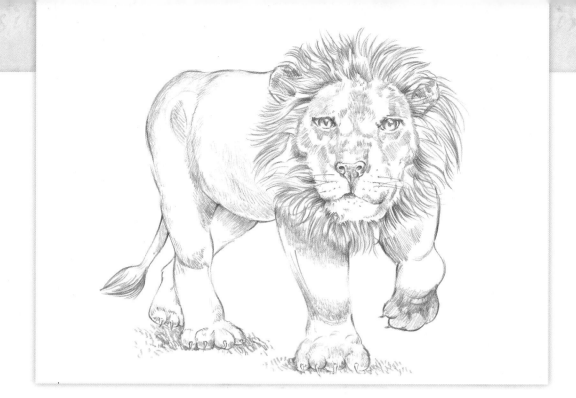

About the Artist

William F. Powell is is an internationally recognized artist and one of America's foremost colorists. A native of Huntington, West Virginia, Bill studied at the Art Student's Career School in New York; Harrow Technical College in Harrow, England; and the Louvre Free School of Art in Paris, France. He has been professionally involved in fine art, commercial art, and technical illustration for more than 40 years. His experience as an art instructor includes oil, watercolor, acrylic, colored pencil, and pastel—with subjects ranging from landscapes to portraits and wildlife. Much of his work has been reproduced as prints and collector's plates, and he has produced numerous contract paintings and illustrations for a variety of publishers. Additionally Bill conducts painting workshops and produces instructional videos that employ unique methods of in-depth presentation and demonstration. Bill holds awards for his technical art, which has been used for major projects, such as space programs and environmental studies. Model making, background sets for films, animated cartoons, and animated films for computer mockup programs have also been part of his work.